Circular Drawings

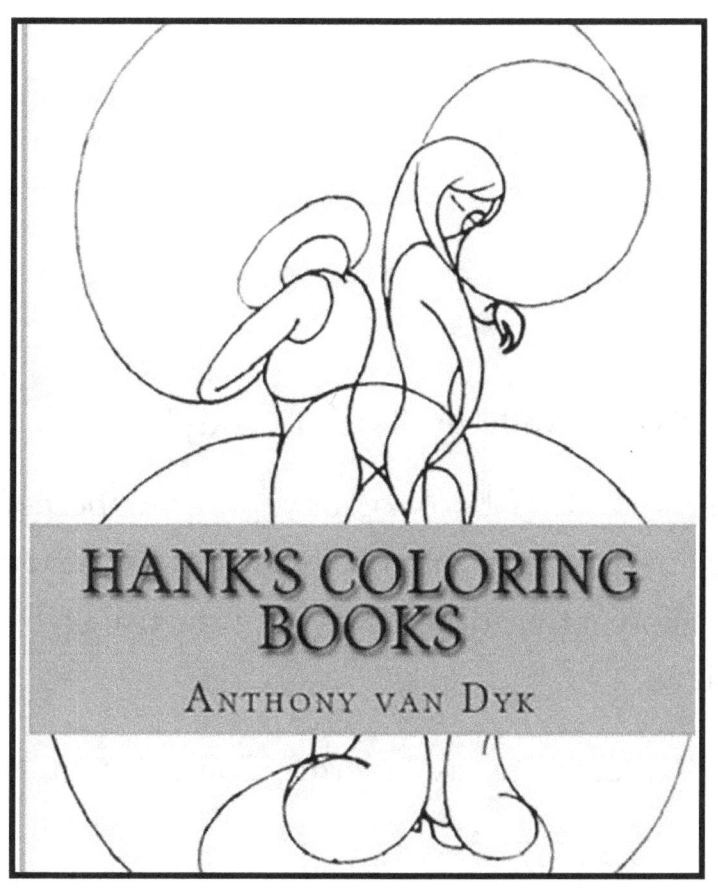

Illustrated by Anthony (Hank) Vandyk

Copyright © 2017 by Anthony (Hank) Vandyk

All rights reserved. This book or any portion thereof may not be reproduced or used in any manner whatsoever without the express written permission of the author except for the use of brief quotations in a book review.

Printed in the United States of America, Columbia, SC

Printed – September 2017

Language: English

ISBN-13: 978-1545378441
ISBN-10: 1545378444

Publisher: CreateSpace Independent Publishing Platform

DEDICATION

I would like to dedicate, Hank's Coloring Books, to my granddaughter, Lizzy, (aka Pumpkin) who from the first time I saw her melted my heart.

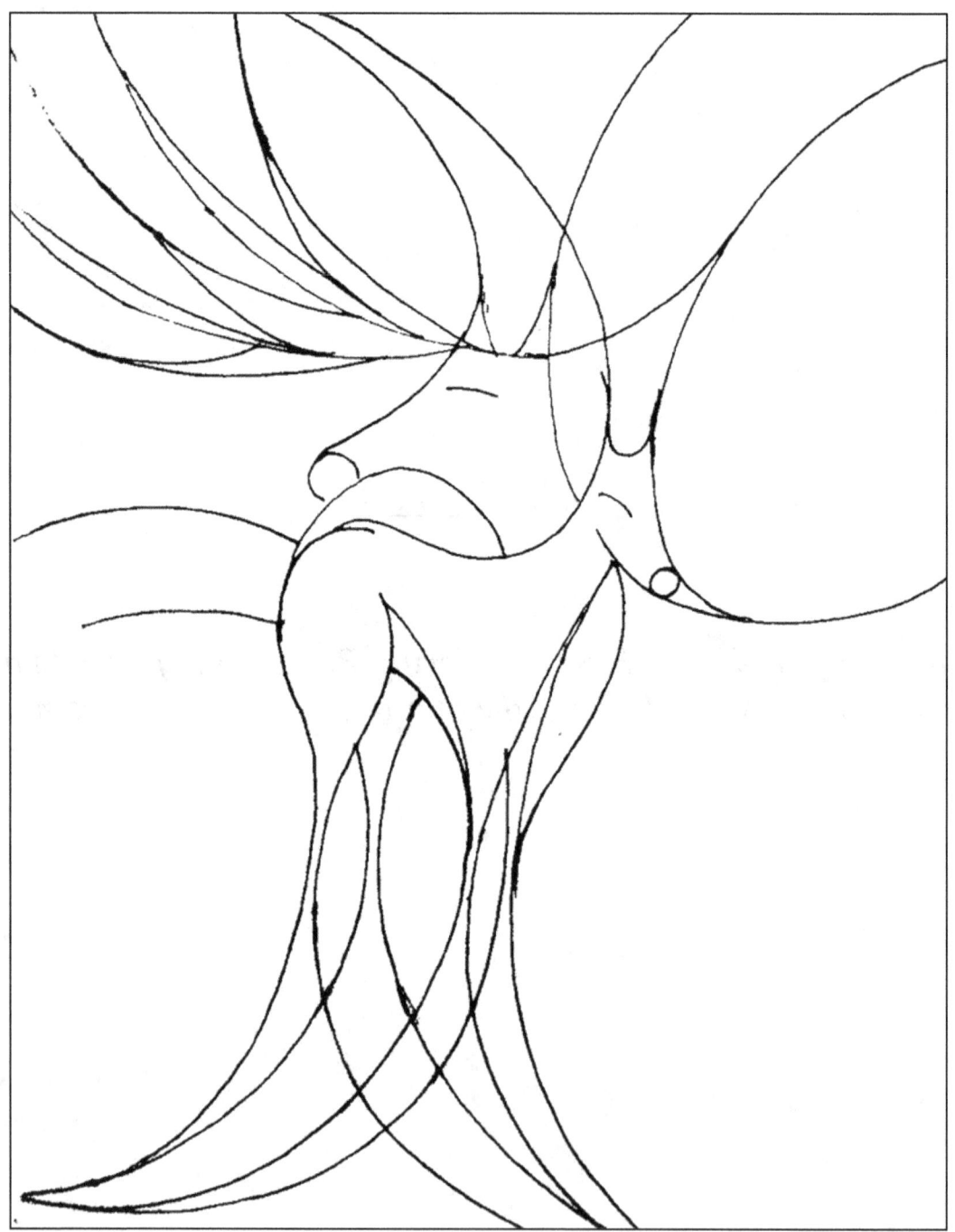

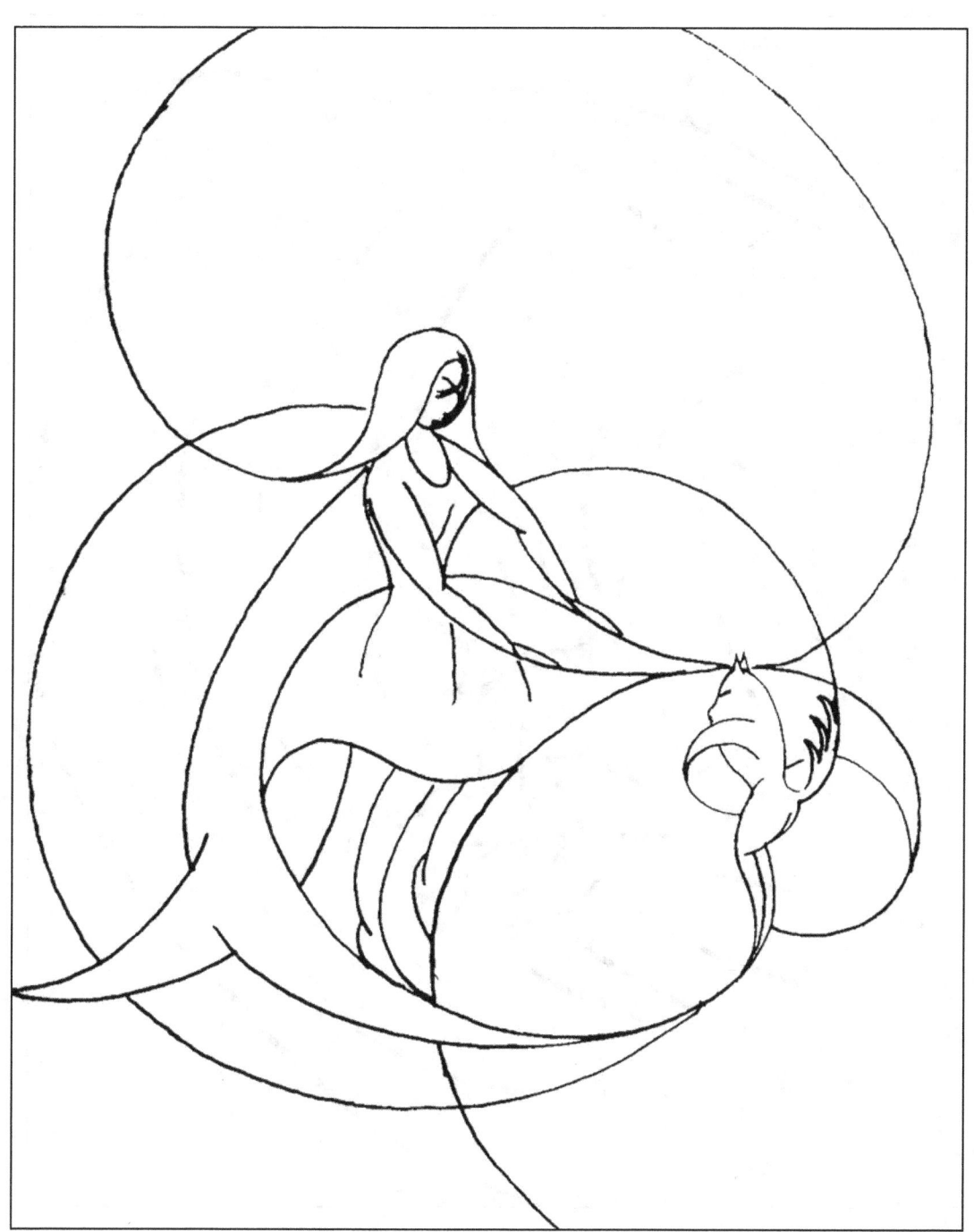

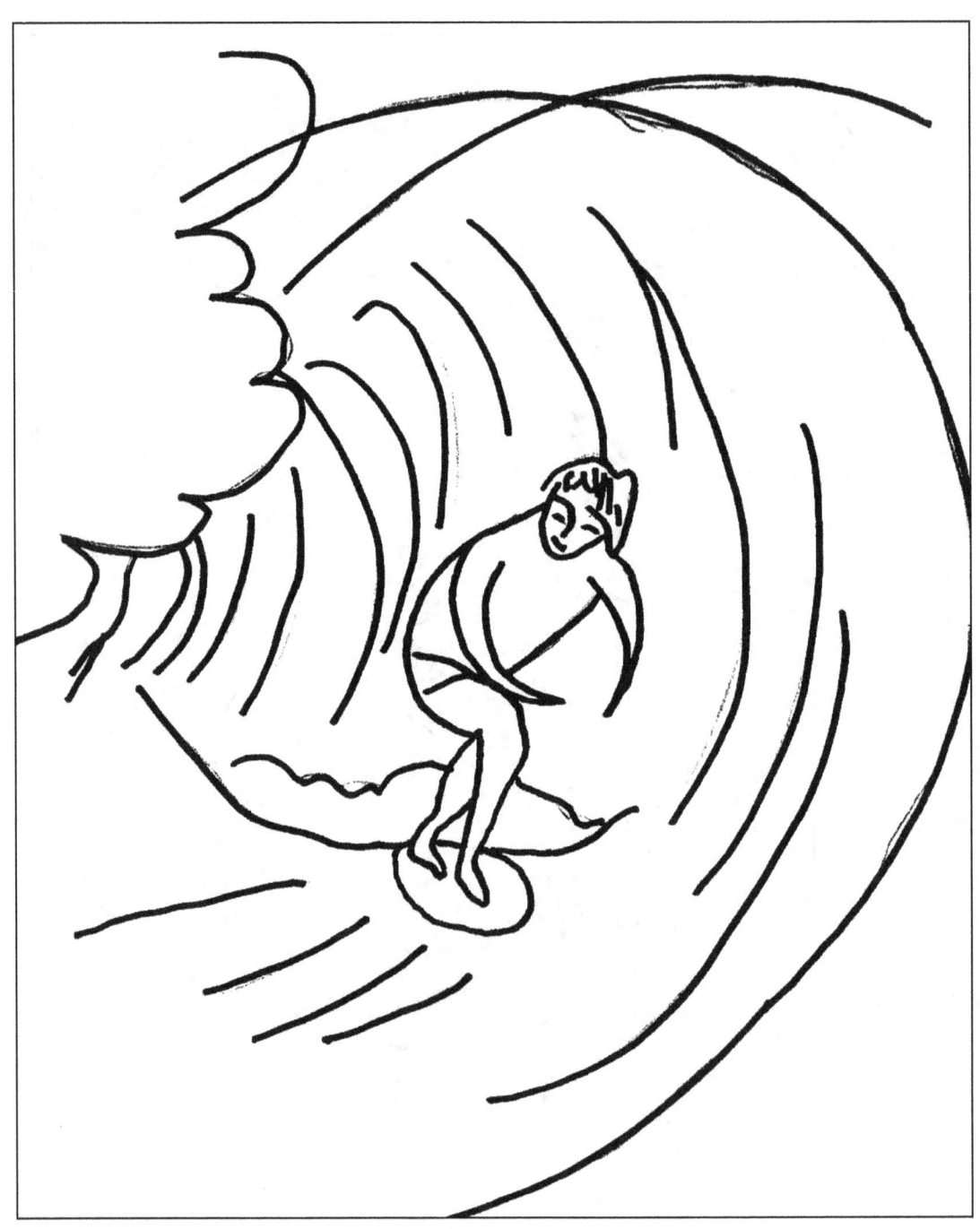

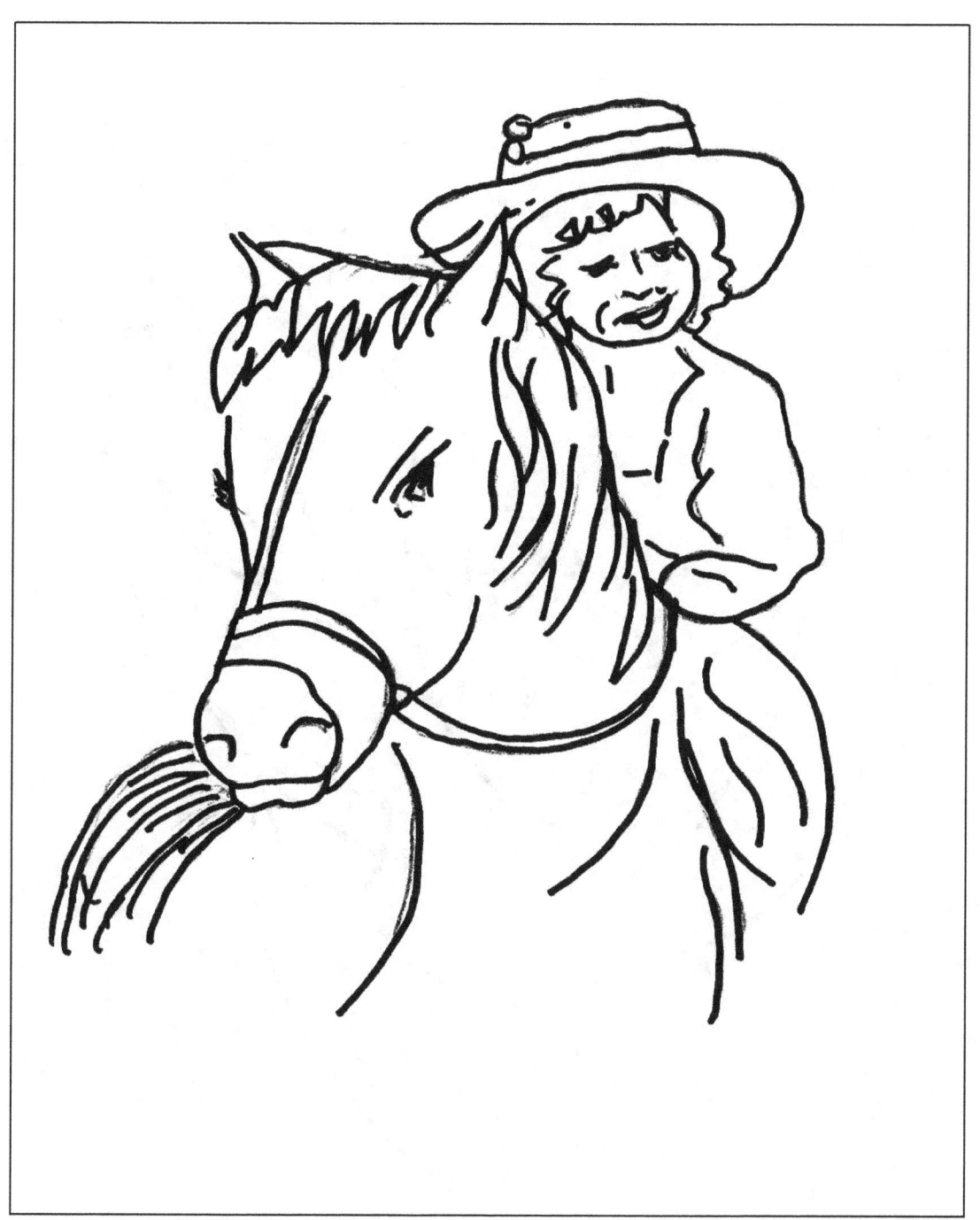

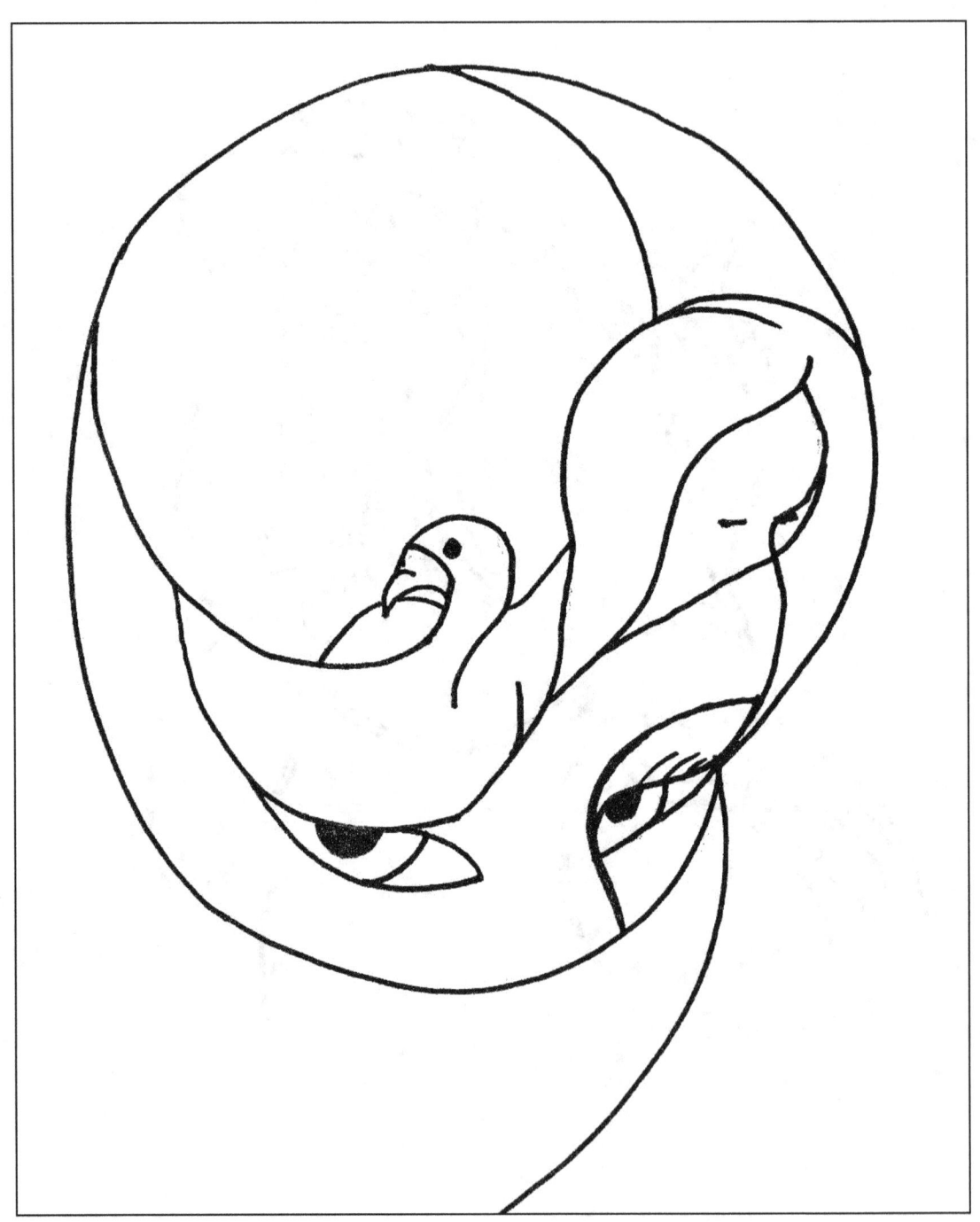

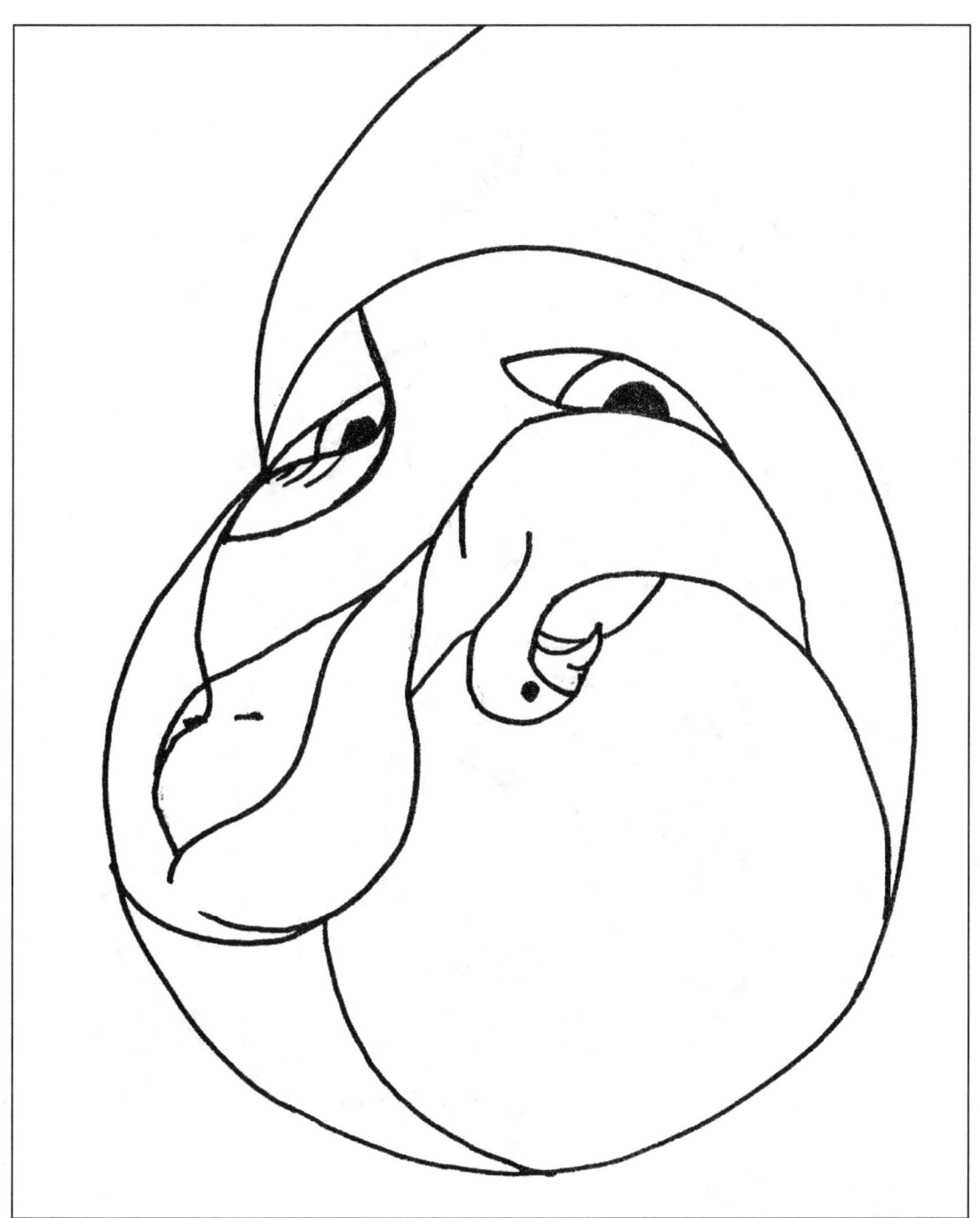

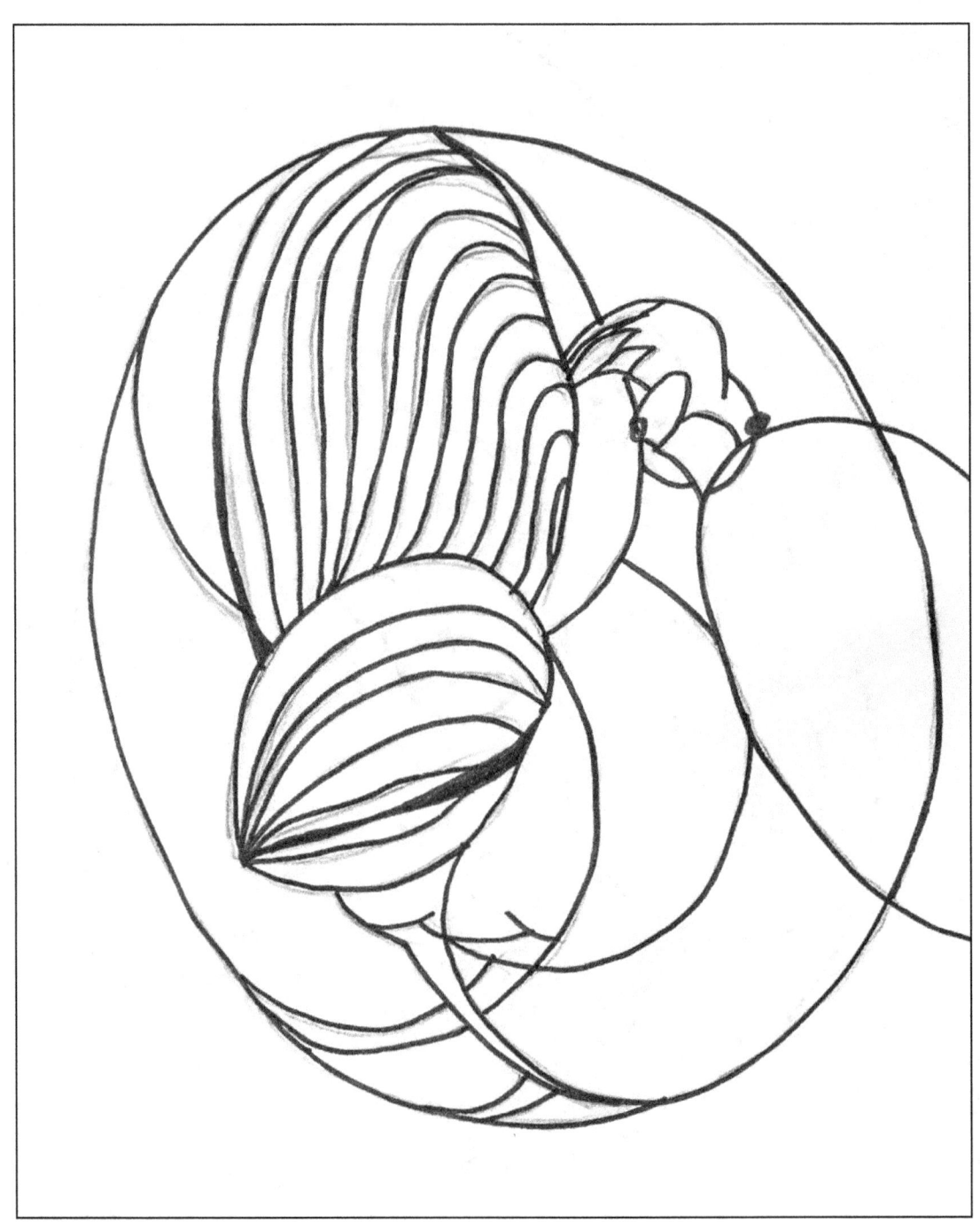

ABOUT THE AUTHOR

Allow me to introduce the author and illustrator of *Hank's Coloring Books*, he is my Opa.

My Opa lives very far away in a country called Canada. I call him Opa because he was born in Holland (Holland is where I live) and Opa is Dutch for Grandpa. My Opa is very clever. He makes beautiful paintings and drawings. He even drew me. He also makes music on his piano and I like that too. I have seen my Opa twice, once when I was quite small and I can't really remember that, but the second time my mommy took me and I was a bit older and I remember it very well. My Opa lives on a boat and that is great! I loved being with my Opa and wished with all my heart I could see him more often. My Opa is a very kind loving man and I love him very much. I love my Opa and Opa loves me.

 Hank was born in Sneek, Holland in 1935. He sold his first painting at the age of fourteen. He enrolled in art school in Amsterdam, where he learned the old Dutch Renaissance style and thereafter became an impressionist. In 1956, he emigrated to Canada, settling in Vancouver where he opened a studio that he ran for 12 years.

Hank having somewhat of a gypsy spirit travelled to the United States, Mexico, Western Europe and Spain all the while fine-tuning his technique. He held exhibitions in San Francisco, New Orleans, Mexico City, Valencia, Barcelona, Alicante, Dortmund, Amsterdam, as well as his hometown of Sneek.

It was in the United State that he met Karl Thorp, an impressionistic painter from New York, who was working in New Orleans at the time.

During his stay in Spain, Hank was influenced by Pedro Delso of Barcelona wherein Hank developed his mosaic technique, a technique that is like no other. The paintings truly must be seen in person to experience their true beauty and the emotion Hank has instilled in them.

Shortly thereafter, he met the French artist, Phillipe Dupireux, who was working in the same impressionist manner as another Frenchman, Edzard.

In 1971, the art critic of the Sneeker Newspaper in Holland responded with more than half a page, detailing Hank's life, his work, and his worldwide recognition. In March of 1973, Hank held an exhibition at the art gallery, Sala Rovira, where he received great reviews from the Barcelona Daily News.

Returning to Canada in 1977, Hank returned to his previous realistic style while working exclusively in Vancouver painting landscapes and the coastal scenery of British Columbia.

Oh... and I encourage you to look at Hank's masterpieces on Fine Art America listed under Anthony (Hank) VanDyk. You will be amazed!

www.ingramcontent.com/pod-product-compliance
Lightning Source LLC
Chambersburg PA
CBHW081318180526
45170CB00007B/2765